What in the World?

In 1911, Italian painter Vincenzo Peruggia stole the *Mona Lisa* from the Louvre, believing it belonged in its country of origin. The painting was recovered two years later.

The Mona Lisa

Jill Kalz

Creative Education

Porta Tonsa

...Alc Des armes
...cesse Ville
...de Milan

...t d'un Serpent per la bouch.
...ang les nobles armes touche,
...ou d'Alexandre Monarque
...ir monnoye à belle marque
...Ammon sous forme Serpentine
...par Semence divine
...ns par bouche Serpenter

Although the *Mona Lisa* was painted in Florence, Italy, it was in the city-state of Milan that Leonardo da Vinci created some of his best-known works, including *The Last Supper* and *The Virgin of the Rocks*.

Introduction

His hands looked quite plain. Nothing extraordinary about them. They pulled on their master's shoes, held a glass of wine to his lips, and plucked notes from a lute. But there was hidden genius in those hands. Given a quill, they drafted plans for irrigation canals, catapults, armored tanks, and flying machines. They drew water wheels, saints, and horses rearing in battle. They sketched the dead swinging from the gallows, dissected the human body, and filled notebooks with the celebration of each bone and sinew. These were the hands of Leonardo da Vinci, and given a brush, they painted the most recognized and admired portrait in the world: the *Mona Lisa*.

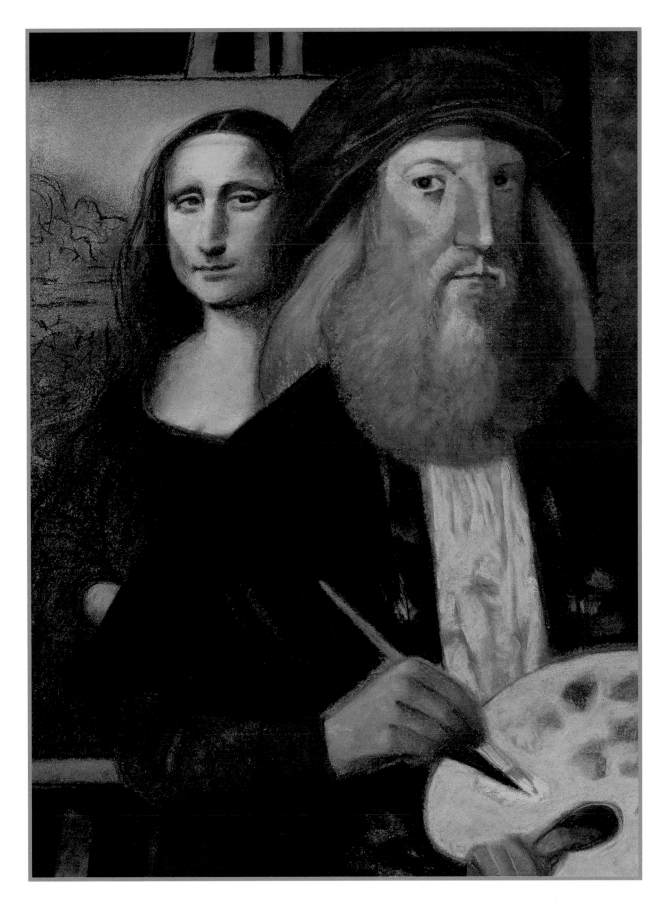

Leonardo da Vinci puts the finishing touches on the Mona Lisa, *in a 21st-century illustration by American artist Gary Kelley.*

Literature and art flourished in Ancient Rome under Augustus Caesar, who ruled from 27 B.C. to A.D. 14.

The Ancient Greeks placed high value on education, as depicted in this school scene illustration from the period.

In the World

Leonardo da Vinci began work on the *Mona Lisa* in Florence, Italy, in 1503, during the height of the Renaissance period. "Renaissance" comes from the French word *renaitre*, meaning "rebirth," and Florence was at the heart of it. Shedding the darkness of the Middle Ages, 15th-century Italian scholars had returned to the art, literature, and philosophy of Ancient Greece and Rome, "The Classics." They encouraged education for all peoples. Emphasis on the intellect of human beings and their lives on Earth replaced the idea that people's lives should be lived solely for heaven-ly rewards. Reliance upon God diminished. Living a full and varied life, expressing oneself as an individual, and questioning authority became the ideal. This new intellectual and cultural movement was called Humanism.

Ancient Greek philosopher Aristotle, 384–322 B.C.

9

While Leonardo painted, the Florentine streets outside his door rang with activity. Eager to build a new society, people flocked to the cities. Bankers, merchants, and tradespeople flourished, generating more than enough money to meet their basic needs. They built bigger and more luxurious homes. They bought fine clothes. They commissioned countless works of art. And they found themselves with more time on their hands—time to devote to intellectual pursuits such as reading, music, and the study of foreign languages. This abundance of wealth, primarily connected to the manufacture and trade of cloth, was

During the Renaissance, Florentine noblewomen wore velvet or silk brocade gowns decorated with pearls, embroidery, or other such trimmings.

Clean drinking water was a rarity in Renaissance Europe. As a result, people of all ages drank ale (a fermented beverage akin to beer) and light wine to quench their thirst, each averaging a gallon (3.8 l) a day.

responsible for elevating many Florentine painters, sculptors, and architects to prominent positions in society.

The Renaissance was a time of expansion, not only mentally, but geographically as well. As European economies improved, demand for imported goods increased, and it became necessary to establish trade with other lands. Cross-country travel was incredibly slow-going, and the roads throughout Europe were poor and frequented by thieves, so most trade was conducted by ship. Explorers set sail for Asia, Africa, and the New World in search of precious gems, silk, and spices such as nutmeg and cinnamon.

Renaissance Italy followed the example of Ancient Rome in teaching its children to read, write, and converse on a variety of topics.

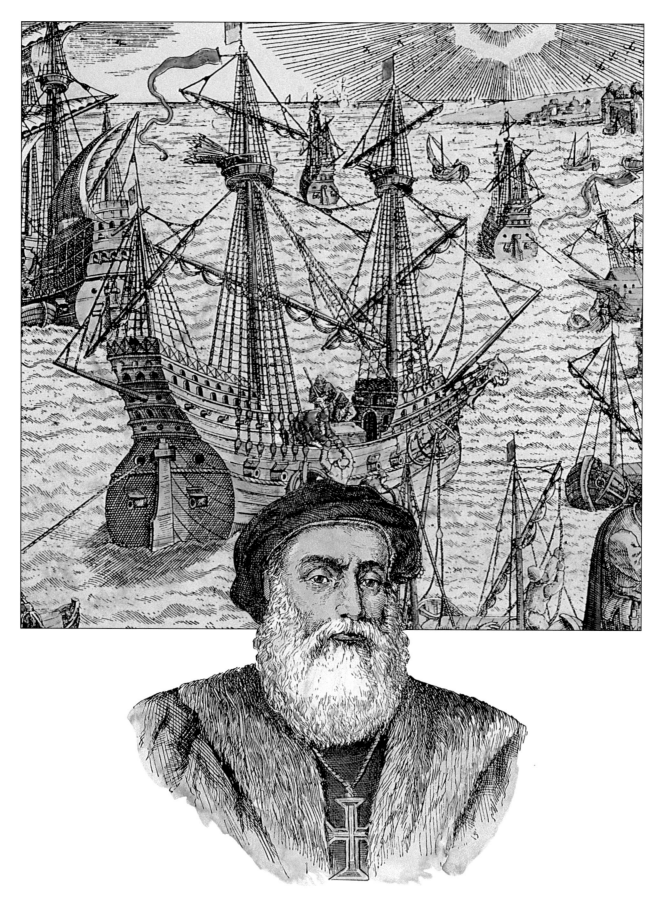

Portuguese explorer Vasco da Gama (1460–1524) navigated a sea route to India, facilitating trade between the East and West.

In the early 1500s, Spanish explorers sailed large ships called galleons around the world in search of new lands. The Russians, too, set sail, under the rule of Ivan the Great, in hopes of finding better trade routes across the Arctic Ocean.

Portuguese explorers ventured most aggressively, lured by the wealth of the Indian Ocean trade. In 1498, Vasco da Gama rounded the coast of South Africa and created the "Cape Route to India." Africa was also a target for Portuguese exploration and colonization. Initially, trade with African rulers centered on gold, silver, and ivory. But by the start of the 16th century, slaves were the major item of commerce, exchanged for cloth, rum, and firearms. Clashes occurred frequently between Portuguese colonists and the African natives. The Africans shot arrows and threw spears, but they were no match for the guns and metal armor of the Portuguese.

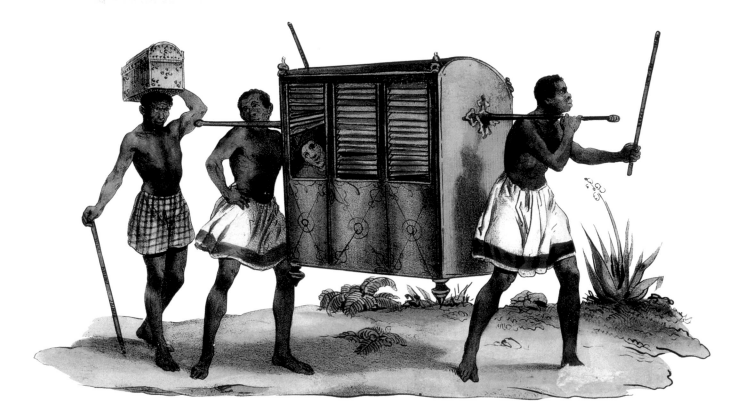

Slaves traded from Africa during the early 1500s often served as litter bearers for wealthy, upper-class Europeans.

At this same time, across the Atlantic, the Inca Empire was flourishing. At its height, the empire stretched from northern Ecuador to central Chile, and from the Andes Mountains to the coast. It was the largest, most advanced empire in the Americas. The Incas based their economy on terraced farming, shaping the mountain slopes and designing ingenious irrigation systems. They built great urban centers and complex road networks. They excelled in metalwork, weaving, and pottery.

An example of Aztec temple architecture, and a piece of fine Incan pottery, molded in the shape of a water bearer.

Cuzco, Peru, was the capital of the Inca Empire for more than 400 years, until the Spanish conquered it in 1535.

Cuzco's Temple of the Sun once boasted a courtyard full of gold statues in the shapes of llamas, corn stalks, and suns.

Farther north, hundreds of native tribes in what is now the United States also thrived. In 1503, permanent mud-brick dwellings, called pueblos, were well established along the Rio Grande and other waterways throughout the Southwest. Elsewhere, nomadic tribes moved with the seasons, erecting temporary bark-covered huts or teepees. All of the native tribes from coast to coast had great respect for nature and the land on which they lived. They clothed themselves in animal skins and furs, turned to the earth for food and shelter, and honored animal deities.

Christopher Columbus (left) "discovered" America in 1492, about the same year this pueblo painting (above) was created.

The Koreans created metal movable type in the 13th century—more than 200 years before it was first used in Europe.

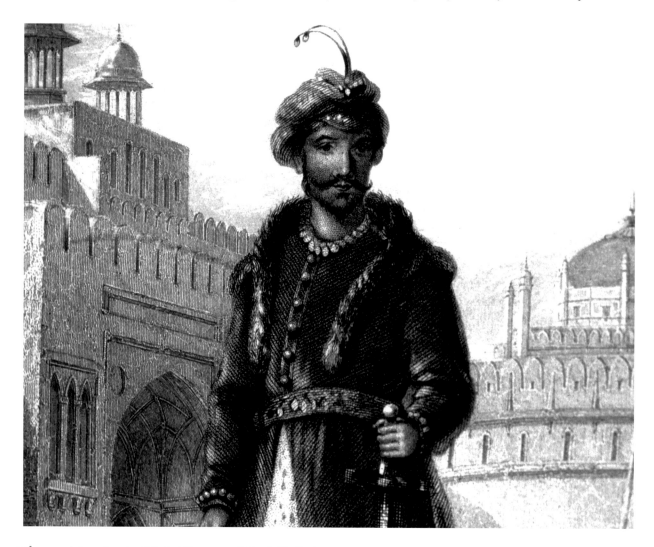

Emperor Humayun belonged to the Mughal Dynasty, which ruled India from 1526 to 1858 and produced such remarkable monuments as the Taj Mahal.

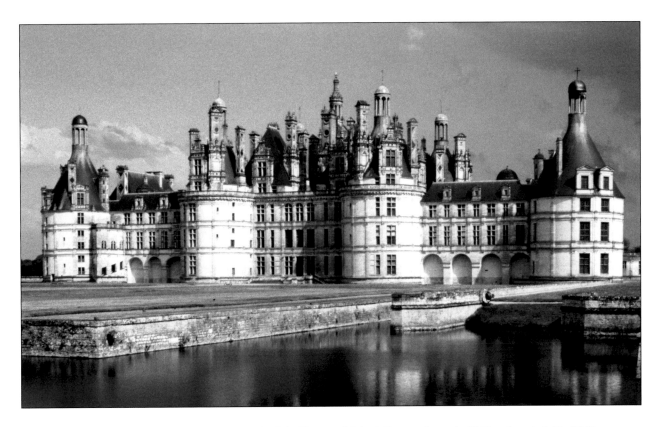

Construction of the opulent Château Chambord, in France, with its 440 rooms, began in 1519 and concluded in 1547.

During the Ming Dynasty (1368–1644), China closed its doors to the outside world. It believed that it had achieved the most satisfactory civilization on Earth, and that there was no need for foreign goods or ideas.

Throughout the world, lands and peoples were being conquered, empires were growing, new inventions were being designed, and future great minds were being born. Everything was expanding. But while grand adventures to new lands did much to bring the world closer together, small gestures played an equally important part. A paintbrush in one man's hand, for example, forever changed the world of art, and its influence can still be felt today, 500 years later.

China's Ming Dynasty produced some of the world's most exquisite ceramic vases, which today can fetch upwards of $5 million apiece.

In His Hands

Leonardo da Vinci was born on April 19, 1452, just outside the small village of Vinci, in Italy's Tuscany region. His father, Piero da Vinci, was a successful notary, and his mother was a peasant woman named Caterina.

Surrounded by rolling hills lined with olive trees and vineyards, Leonardo had ample opportunities to observe nature firsthand. It was in Tuscany where he first developed his fascination with all things that twisted and curled—vibrant, living things. Piero recognized his son's artistic gift early on and, in 1466, apprenticed Leonardo to the great master Andrea del Verrochio, who at the time was the leading sculptor and painter in Florence.

The inquisitive 14-year-old worked side-by-side with his master, completing many of his master's works, as apprentices often did. He learned the arts of sculpture, painting, and casting. After a time, Verrochio realized that his pupil was developing a keener eye for painting than his own. Leonardo's subjects showed a kind of vitality previously unseen in other artists' works.

> **Leonardo was by many accounts a gentle, compassionate man. He adhered to a strict vegetarian diet and was known to buy caged birds from market vendors just to set them free.**

Tuscany is known for its sprawling vineyards and olive tree orchards, the fruits of which are all picked by hand.

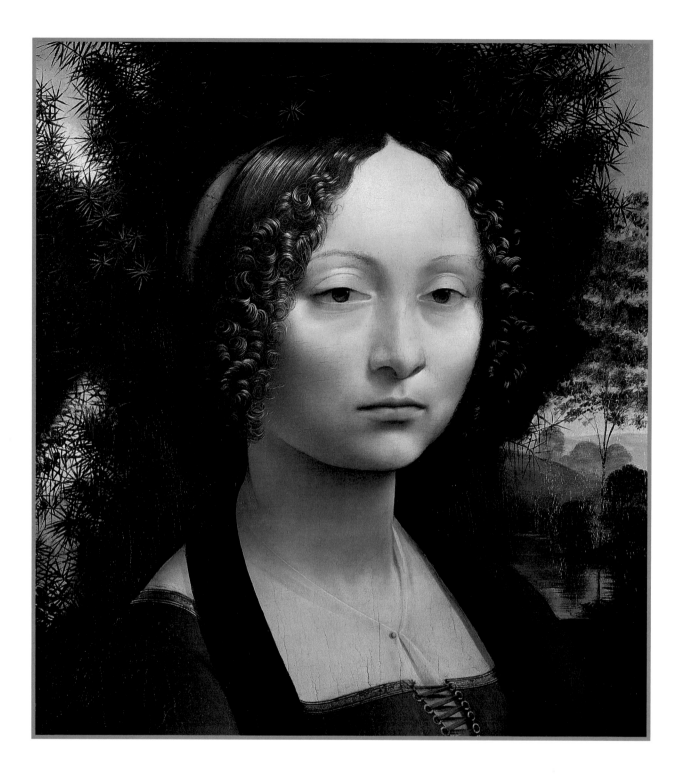

Portrait of Ginevra de'Benci *foreshadowed the "sfumato" technique which Leonardo later perfected in the* Mona Lisa.

In 1503, Florence was a self-governed, independent city-state; Italy did not yet exist as a unified country. The Medici, the wealthiest and most influential family in Florence, ruled the city for nearly 300 years.

Florence produced some of the greatest minds of the Italian Renaissance: Dante (poetry); Machiavelli (prose); Botticelli, Leonardo da Vinci, and Giotto (painting); and Michelangelo (sculpture).

Soon after the completion of his apprenticeship 12 years later, Leonardo came under the patronage of the wealthiest, most influential man in Florence: Lorenzo de' Medici, who ruled the city from 1469 to 1492. Having acquired their fortune through banking, the Medici sponsored Florence's first library and many public works. Their patronage of the arts, in addition to that of the Church, turned Florence into Europe's most prominent cultural center.

From Lorenzo, Leonardo received commissions for two of his first well-known works, *Portrait of Ginevra de'Benci* (1478–80) and *Adoration of the Magi* (1481–82). But in 1482, at the age of 30, he moved to Milan, leaving *Adoration* unfinished. Surprisingly, it was not his talents as an artist that gained him favor with the duke of Milan, Ludovico Sforza; it was his singing voice and proficiency on the lute. In fact, in a letter to the duke, Leonardo downplayed his talents as an artist, referring to himself as an "engineer" first and foremost.

Lorenzo "The Magnificent" de' Medici (1449–92) influenced Florentine entertainment by sponsoring plays, horse races, and festivals.

Thanks in part to the patronage of Ludovico Sforza (below), Leonardo was able to explore the possibility of human flight.

The court of Sforza was filled with men of science. And the ever-inquisitive Leonardo thrived in this environment. As court engineer and painter, he studied geometry, physics, and anatomy. He honed his observation skills. Although a peaceful man by nature, he drew military devices, improving designs for various weapons and defense mechanisms. He spent years working on a giant equestrian statue of Ludovico Sforza's father, only to have the 150,000 pounds (67,500 kg) of bronze intended for its casting taken away at the last minute and used to manufacture cannons. He drafted architectural plans for cathedrals and sketched fantastic flying machines. He even wrote music, designed costumes, and staged elaborate theatrical productions.

Leonardo painted left-handed. He also wrote left-handed, moving across the page from right to left, producing a sort of backwards "mirror script."

Leonardo filled notebooks with complex mechanical sketches (right) whose principles were often years ahead of their time.

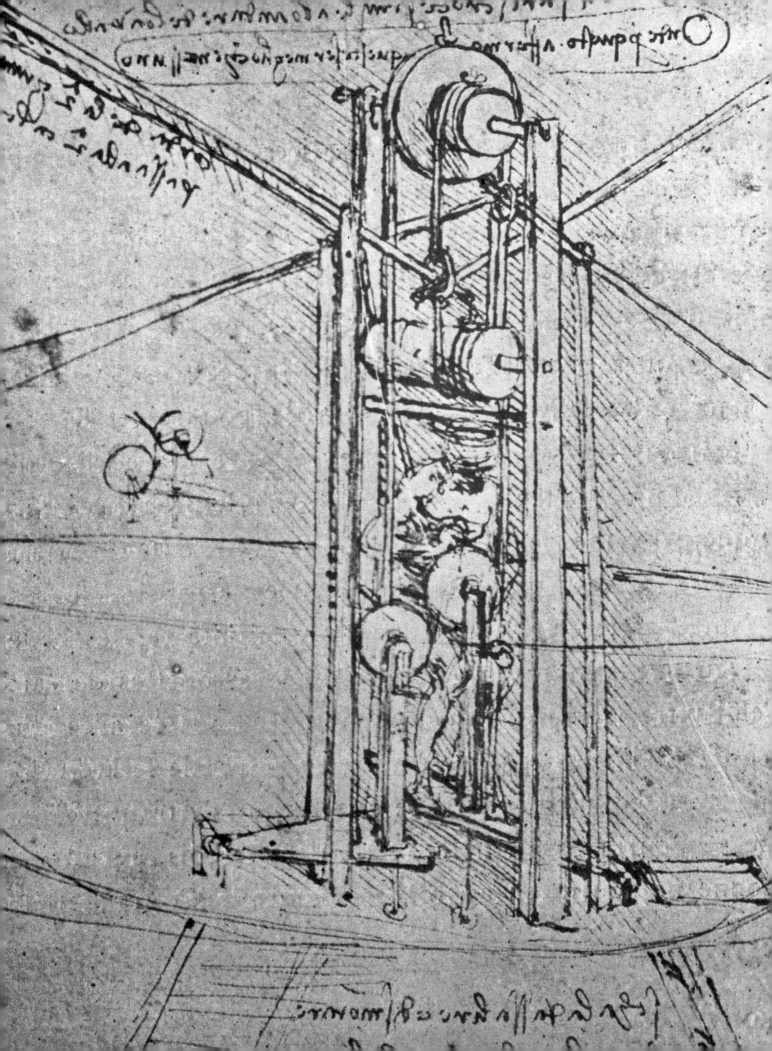

Leonardo's many animal sketches included studies of birds in flight (inset), which led to plans for marvelous flying machines.

Leonardo had an insatiable appetite for learning, and he experimented constantly. Unfortunately, his eagerness to explore new things and his quest for perfection meant that many projects were left unfinished. Notebooks full of ideas were never realized. Either there wasn't time to see them all to completion or the means didn't yet exist to make them work.

Some of his "experiments" had devastating effects. For one of his most ambitious art commissions, *The Last Supper* (1495–98), Leonardo shunned the traditional fresco style (using watercolors on wet plaster)

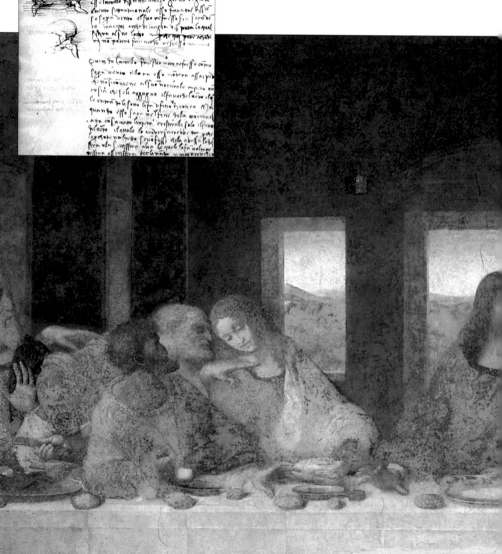

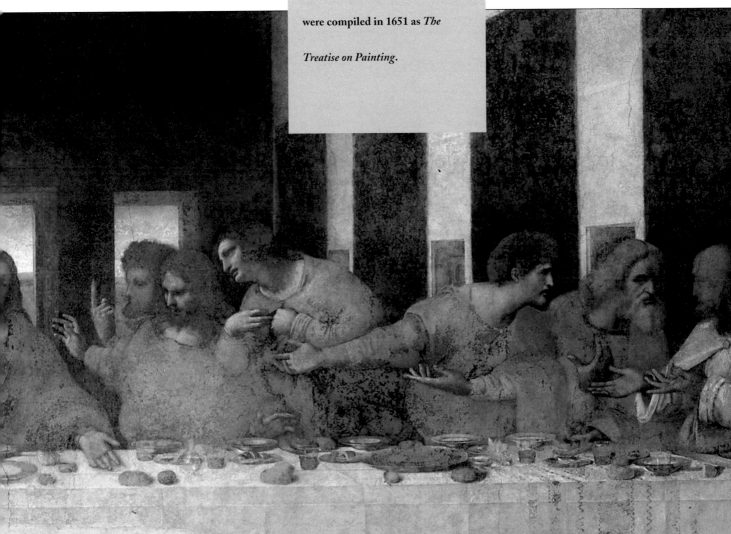

During a 22-year restoration project begun in 1977, countless layers of dust and grease were removed from The Last Supper.

for a new, untested tempera-based technique, hoping to save time. (Tempera paints are pigments mixed with egg yolk.) The exquisite painting began to deteriorate almost as soon as work on it concluded, and almost nothing of the original work exists today.

Throughout this time, Leonardo's fascination with the human body never faltered. He attended medical anatomy demonstrations, sketched the dead at public executions, and years later even performed human dissections. Around 1492, Leonardo completed his drawing *Vitruvian Man*, his interpretation of the teachings of Roman architect Vitruvius

In Milan, Leonardo took on apprentices and pupils to earn his living. He filled notebooks with "lessons" on how to paint, which were compiled in 1651 as *The Treatise on Painting*.

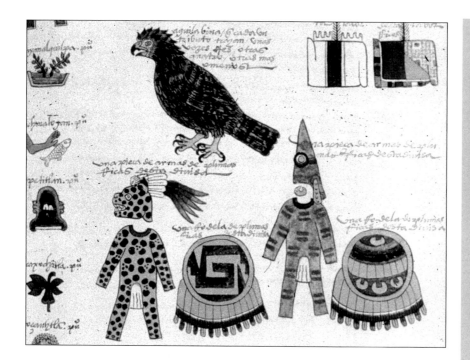

on the proportions of the human body. Vitruvius claimed that the human form, lying face up, hands and feet extended, could be enclosed within both a circle and a square. Leonardo proved this claim with his drawing.

In 1499, the French invaded Milan and imprisoned high-ranking noble-men, including Ludovico Sforza, thus bringing Leonardo's patronage to an end. With Sforza locked away, Leonardo left Milan and headed east, likely in search of new sources of income. A year later, he found himself back in Florence—20 years after he'd first left for Milan.

It was 1500, and as the tall artist with the reddish beard walked the streets

In contrast to the art of the Renaissance, a primitive drawing from the Aztec empire illustrated town taxes for the emperor.

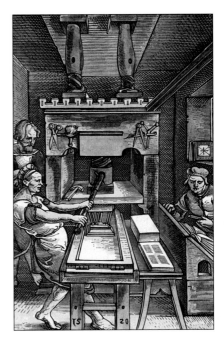

Before Gutenberg's printing press, in the mid–15th century, all books in Europe were written by hand.

Florentine gold coins (florins) were Europe's purest.

Leonardo drew Vitruvian Man *while researching a book project (which he never finished) called* On the Human Figure.

Ivan the Great ruled Muscovy (Russia) from 1462 until his death in 1505.

Contrary to tradition, Michelangelo chose to portray David before his Biblical battle with the giant Goliath, not after.

of Florence, the name "Michelangelo" hung on the lips of nearly every passer-by. Michelangelo Buonarroti, nearly a full generation younger than Leonardo, had gained a reputation as an outstanding artist in Florence. His studies of muscular male nudes would soon lead him to sculpt his famous marble statue *David*. As Leonardo's reputation both inside and outside the borders of Italy at this time was no less brilliant,

Michelangelo's *David* is carved from a single block of marble and stands more than 14 feet (4.3 m) tall.

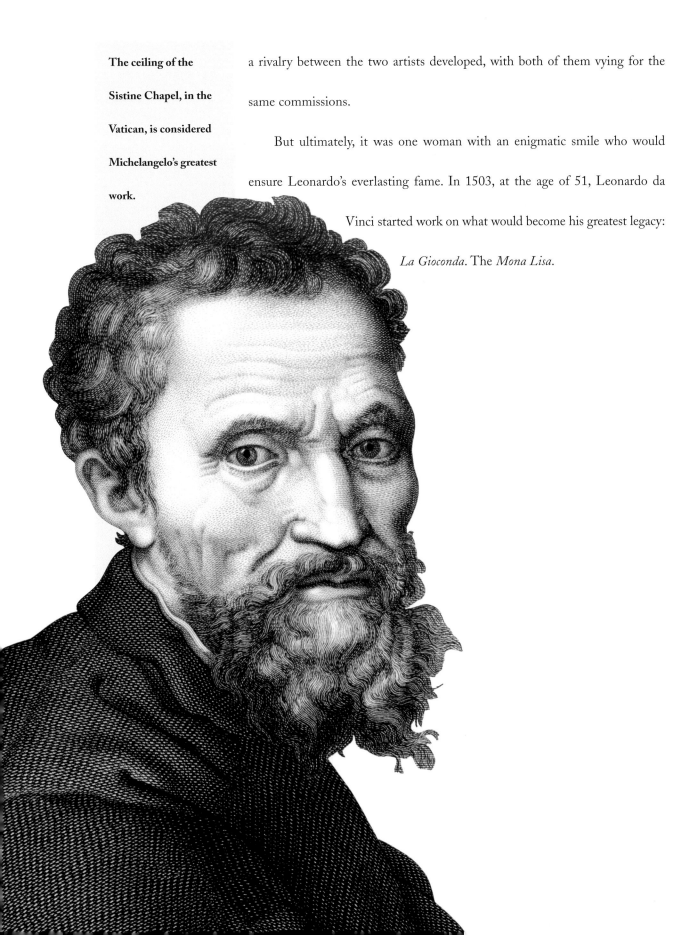

Artist Michelangelo Buonarroti (1475–1564) excelled in many areas, including sculpture, painting, architecture, and even poetry.

The ceiling of the Sistine Chapel, in the Vatican, is considered Michelangelo's greatest work.

a rivalry between the two artists developed, with both of them vying for the same commissions.

But ultimately, it was one woman with an enigmatic smile who would ensure Leonardo's everlasting fame. In 1503, at the age of 51, Leonardo da Vinci started work on what would become his greatest legacy:

La Gioconda. The *Mona Lisa.*

In Her Smile

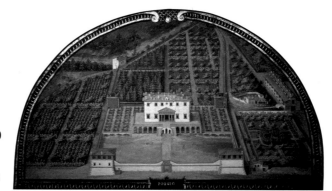

Measuring just 30 by 20-7/8 inches (77 x 53 cm), the *Mona Lisa* began its life as a thin panel of treated poplar wood. Leonardo first drew his model's likeness onto the wood, and then painted her in oil. He applied layer after layer of transparent color, called glaze, to create a seamless blend of light and shade.

The *Mona Lisa* is a triumph in two of the most important painting techniques to arise from the Renaissance period: sfumato and chiaroscuro. Sfumato comes from the Italian word *sfumare*, which means "to evaporate, like smoke." Subtle transitions between color areas give the portrait a hazy, dreamlike feel. Lines are softened, and tones blur (or evaporate) into one another. This technique can be seen in the *Mona Lisa*'s robes and famous smile. During the Renaissance, Leonardo was the undisputed master of sfumato. No one could match his skill, though he inspired many—both novice painters and seasoned contemporaries—to try.

Leonardo didn't like to paint by bright sunlight, preferring instead the pale light that filtered through low-lying clouds. He believed a subject's true character was best revealed in dim, evening light and bad weather.

During the 16th century, the Medici of Florence resided in 14 grand villas, one of which is depicted in this lunette (semicircular painting) of the times by Flemish artist Giusto Utens.

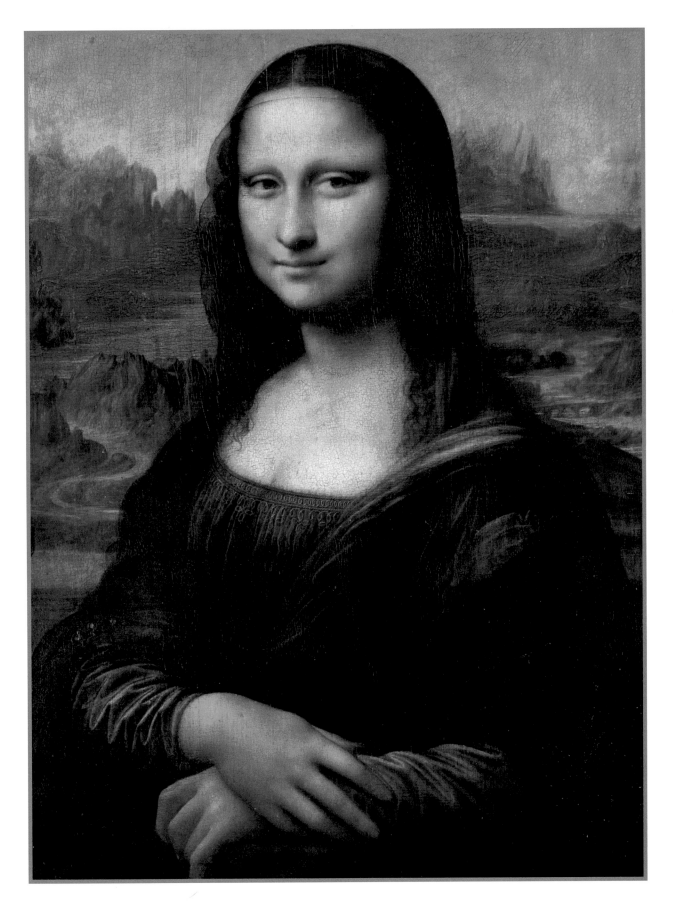

No other portrait in the world is as recognizable as Leonardo da Vinci's Mona Lisa.

Chiaroscuro plays with light and shadow. This technique allowed Leonardo to model and define parts of the *Mona Lisa* not by changing colors, but by changing the amount of light certain areas received. Using chiaroscuro, Leonardo could depict three-dimensional shapes in a two-dimensional form. The *Mona Lisa*'s hands, for example, are created using the chiaroscuro technique. It is as if the hands appear out of complete darkness.

Throughout the Middle Ages, saints and other religious figures were the subjects of most paintings, which were created primarily to teach the word of the Bible. Portraits were reserved for nobility. Two-dimensional and often arranged in unnatural positions, figures appeared flat and lifeless against simple gold backgrounds. As a result, paintings seldom connected with people on an emotional level. The *Mona Lisa* represented a firm departure from this style and embraced all that the Renaissance represented: an intimate return to the human form and a realistic representation of the world.

From January 8 to February 3, 1963, the *Mona Lisa* hung in the National Gallery in Washington, D.C., as a special one-picture loan from the French government to President Kennedy and the American people.

The Tokyo National Museum welcomed the *Mona Lisa* to Japan in 1974. It attracted more than 1.5 million visitors during its short visit and set an exhibition attendance record that has yet to be broken.

During the Middle Ages, paintings looked very two-dimensional, as in this depiction of Christ with St. Peter and St. James from 1240.

Prior to the Renaissance, the Church had a great deal of influence over the subjects and messages artists depicted.

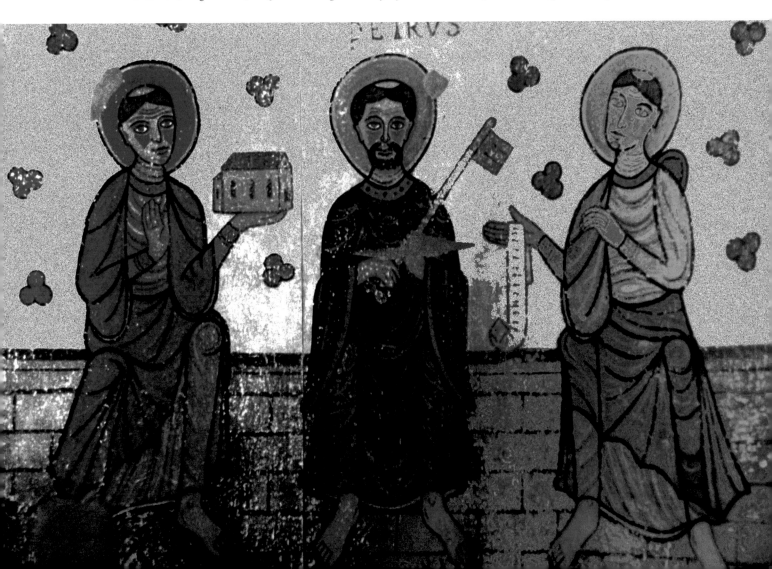

Leonardo painted the *Mona Lisa* as a half figure, turned two-thirds toward the viewer. He moved his subject closer to the front edge of the painting to create a sense of intimacy. An expert anatomist, Leonardo understood the relationships between different parts of the body, the measurements and angles of the face. He understood how muscles and bones moved beneath the skin. His acute, firsthand knowledge of the body lent vitality and accuracy to his subject.

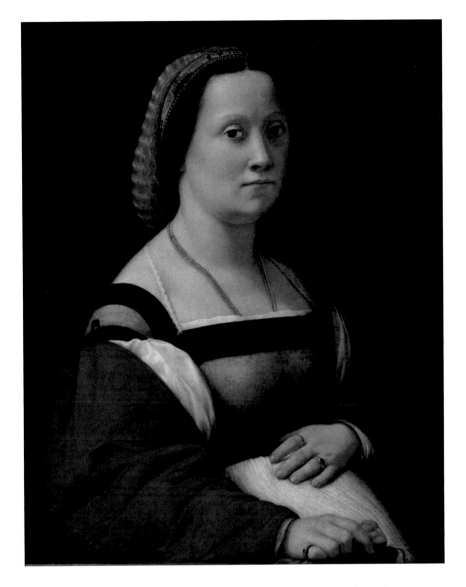

Leonardo was one of the first artists to bring a feeling of dimension and intimacy to his paintings. The sfumato and chiaroscuro techniques helped him give the subject of the *Mona Lisa* fullness and life. But his meticulous rendering of the craggy landscape behind her, his use of light and shadow there, also created depth and pushed the subject out toward the viewer. Fellow Florentine masters of the time, including Raphael, Andrea del Sarto, and Fra Bartolommeo, visited Leonardo often during his work on the *Mona Lisa* and studied his style and technique, borrowing what they could for their own work.

Italian painter Raphael (1483–1520) used many of Leonardo's techniques in his 1506 portrait entitled La Donna Gravida.

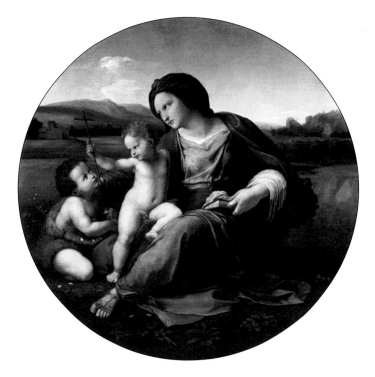

After the creation of the Mona Lisa, *portraiture took a more realistic turn, as in these paintings by Raphael (above and below).*

Many of the techniques used in the Mona Lisa *later found their way into other artists' works, including this 1518 painting by del Sarto (right).*

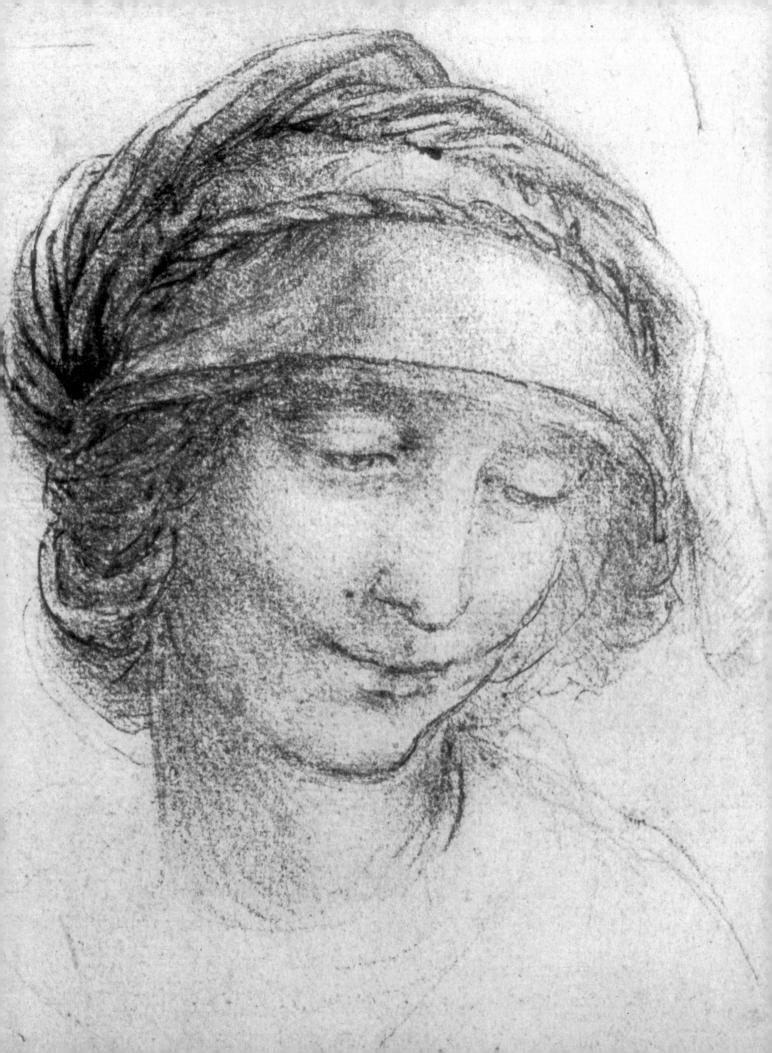

When France entered World War II in 1939, most of the Louvre's works of art, including the *Mona Lisa*, were loaded onto freight trains and taken to protected storage facilities outside Paris.

In 1517, Leonardo accepted an invitation from King Francis I of France to serve as court painter and architect. The home given to him in Cloux, near the royal castle, was his last.

As the only sources of light in 1503 were the sun and fire, Leonardo painted by day when he could. Smoking resin torches, tallow candles, and oil lamps lit his studio at night and cast flickering shadows on the walls. It is amazing to note that all of the great masters of the Renaissance period (and before) created their works of art primarily by the light of a flame—even the ceiling of the Sistine Chapel!

Most historians agree that the subject for the *Mona Lisa* was 24-year-old Lisa Gherardini Giocondo, the wife of wealthy Florentine gentleman Francesco del Giocondo. It is thought that Francesco commissioned the portrait to celebrate the recent birth of his son and the completion of a new home. Little is known of Lisa's life except that her marriage to Francesco in 1495, at the age of 16, was an advantageous one. Having come from a family of considerably less wealth, Lisa "married well" and was lucky enough to gain a husband who cared a great deal for her. Many marriages during the Renaissance were arranged for political or social gain and had little to do with love.

Leonardo often made many studies, or sketches, of his subjects in chalk before painting them, such as this study of St. Anne.

Some people claim that the subject for the *Mona Lisa* was not Lisa del Giocondo, but a mistress of Giuliano de' Medici, one of the powerful Medici of Florence. Others believe her to be a young boy dressed as a woman—or even Leonardo himself! And still others think she is simply a representation of the feminine ideal and based on no real person at all. Whoever she was, Leonardo had a special fondness for the painting, as he took it with him on all of his subsequent travels. No one knows for certain when work on the *Mona Lisa* concluded, but most scholars place it around 1506. Leonardo never delivered the portrait to his client.

Today, Leonardo da Vinci is remembered as a painter, sculptor, engineer, architect, and scientist. He is called a "universal genius." His triumph, the *Mona Lisa*, hangs behind glass, under heavy surveillance, in the Louvre Museum in Paris. Seen by many as a symbol for art itself, the *Mona Lisa* is literally priceless, its worth far exceeding the confines of money. Much has changed since 1503, but the smile that Leonardo first pulled from that piece of poplar wood 500 years ago continues to inspire, perplex, and enchant the world.

No one knows where Leonardo's grave is. His body was buried in 1519 inside the palace church of King Francis I of France, but both the palace and the church were destroyed during the French Revolution.

Only one portrait of Leonardo exists today. Drawn around 1512, when he was in his early 60s, the red chalk drawing portrays Leonardo as a much older man. Scholars question whether it is an authentic self-portrait or a fake.

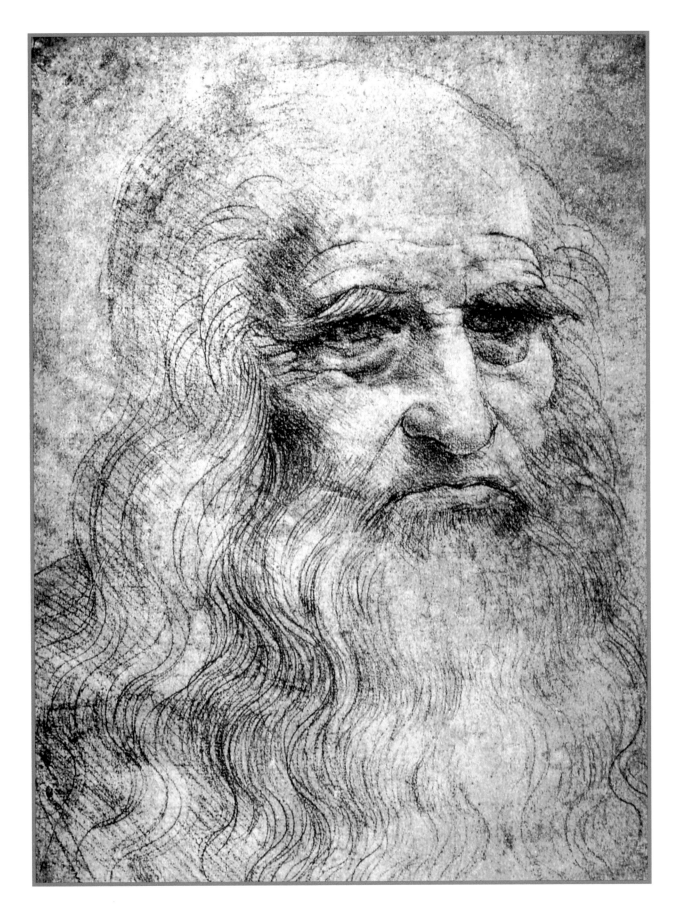

Once thought to be a self-portrait of Leonardo, this chalk drawing is today considered a fake, or at best a copy, by many scholars.

The *Mona Lisa* moved to a new, more spacious home within the Louvre in 2003. It now has a 240-square-yard (200 sq m) gallery of its own to accommodate the more than six million annual Louvre visitors.

Leonardo said, "The painter will produce pictures of small merit if he takes for his standard the pictures of others, but if he will study from natural objects he will bear good fruit."

What in the World?

1452 Leonardo da Vinci is born in Tuscany

1453 End of Hundred Years' War between England and France

1454 German printer Johann Gutenberg uses movable metal type, the first in Europe

1455 First indoor bowling lane is created in London, England

1466 Leonardo becomes apprenticed to Verrocchio

1475 Constantinople (now Istanbul, Turkey) welcomes world's first coffeehouse

1481 Beginning of the Spanish Inquisition (religious persecution akin to witch hunts)

1485 Leonardo designs an early version of the parachute

1490 Cast-iron stoves first come into use, in northern France

1492 Christopher Columbus sets sail for the New World

1493 Pineapples are brought to Europe from the Caribbean by Spanish explorers

1498 The Chinese invent toothbrushes with bristles

1499 Black Death epidemic hits London, kills thousands in next two years

1500 World population exceeds 500 million

1503 Leonardo begins work on the *Mona Lisa*

1510 German locksmith Peter Henlein creates the pocket watch

1512 Astronomer Nicolaus Copernicus claims Earth revolves around the sun

1513 Spanish explorer Ponce de León discovers Florida

1517 Martin Luther leads the Protestant Reformation in Germany

1519 Leonardo da Vinci dies in Cloux, France

Leonardo's Codex Leicester, an illustrated manuscript like this one, brought in an astounding $30.8 million at a 1994 auction.

Copyright

Published by Creative Education
123 South Broad Street, Mankato, Minnesota 56001

Creative Education is an imprint of The Creative Company.
Design by Rita Marshall

Photographs by: Art Resource, NY (Alinari, Cameraphoto, Werner Forman, Erich Lessing, The Newark Museum, Réunion des Musées Nationaux, Scala), Corbis (Bettmann, Stefano Bianchetti, Historical Picture Archive, Araldo de Luca, Francis G. Mayer), Historypictures.com, North Wind Picture Archives (8, 10, 11, 12, 15, 29, 41), N. Carter/North Wind Picture Archives (17), Leonardo da Vinci; Ginevra de'Benci; Ailsa Mellon Bruce Fund; Image © Board of Trustees, National Gallery of Art, Washington

Illustrations: copyright © 2005 Etienne Delessert (6, 16, 20, 36), copyright © 2005 Gary Kelly (2, 7, 21, 44)

Copyright © 2005 Creative Education.

Library of Congress Cataloging-in-Publication Data
Kalz, Jill. The Mona Lisa / by Jill Kalz.
p. cm. — (What in the world?)
Summary: A biography of Leonardo da Vinci, focusing on the innovative painting techniques he used to create one of the most recognized and admired portraits in the world: The Mona Lisa.
ISBN 1-58341-272-7
1. Leonardo, da Vinci, 1452-1519. Mona Lisa—Juvenile literature. 2. Leonardo, da Vinci, 1452-1519—Juvenile literature. 3. Artists—Italy—Biography—Juvenile literature. [1. Leonardo, da Vinci, 1452-1519. Mona Lisa. 2. Leonardo, da Vinci, 1452-1519. 3. Artists.] I. Title.
ND623.L5 A7 2003 759.5—dc21 2002191174

First Edition
9 8 7 6 5 4 3 2 1

Index